MY NOTES

MY NOTES

Color Testing Page

www.ingramcontent.com/pod-product-compliance
Lightning Source LLC
Chambersburg PA
CBHW020711180526
45163CB00008B/3042